LA GRANGE PUBLIC LIBRARY

3 1320 00282 5391

MW01293401

WITHDRAWN

LaGrange Public Library
LaGrange, Illinois 60525
708-352-0576

America's First Peoples

The Cherokee

Native Basket Weavers

by Therese DeAngelis

Consultant:
Chief Walking Bear Wilson
Amonsoquath Tribe of Cherokee
Ellsinore, Missouri

LA GRANGE PUBLIC LIBRARY
10 WEST COSSITT
LA GRANGE, ILLINOIS 60525

Blue Earth Books

an imprint of Capstone Press
Mankato, Minnesota

Blue Earth Books are published by Capstone Press
151 Good Counsel Drive, P.O. Box 669, Mankato, Minnesota 56002
http://www.capstone-press.com

Copyright © 2003 by Capstone Press. All rights reserved.

No part of this book may be reproduced in whole or in part, or stored in a retrieval system, or transmitted in any form
or by any means, electronic, mechanical, photocopying, recording, or otherwise, without written permission from the publisher.
For information regarding permission, write to Capstone Press, 151 Good Counsel Drive,
P.O. Box 669, Dept. R, Mankato, Minnesota 56002.
Printed in the United States of America

Library of Congress Cataloging-in-Publication Data
DeAngelis, Therese.
 The Cherokee : native basket weavers / by Therese DeAngelis.
 p. cm. — (America's first peoples)
Summary: Discusses the Cherokee Indians, focusing on their tradition of weaving baskets. Includes a cookie recipe and instructions for playing a game and making a mat.
 Includes bibliographical references and index.
 ISBN 0-7368-1535-X (hardcover)
 1. Cherokee Indians—Juvenile literature. 2. Cherokee baskets—Juvenile literature. [1. Cherokee Indians. 2. Indians of North America. 3. Indian baskets.] I. Title. II. Series.
E99.C5 D43 2003
746.41'2'0899755—dc21
 2002012534

Editorial credits
Editor: Megan Schoeneberger
Series Designer: Kia Adams
Photo Researcher: Jo Miller
Product Planning Editor: Karen Risch

Cover images: woman weaving basket, Corbis; baskets (inset), Kent and Donna Dannen

Photo credits
Ann & Rob Simpson, 10 (bottom left)
Camera Arts, Inc./Rod Patterson, 16 (baskets)
Capstone Press/Gary Sundermeyer, 3 (all), 7 (right),
 14 (right), 15 (all), 16 (berry), 19, 23
Cherokee Historical Association, 14 (left)
Corbis/Peter Turnley, 11
Dorothy Tidwell Sullivan, 5, 27
Getty Images/Hulton Archive, 6–7
Jeanne Rorex Bridges, 18
Kent and Donna Dannen, 21 (right)
Kit Breen, 13 (both), 20–21, 22, 24–25
Marilyn "Angel" Wynn, 4, 10 (top right), 12, 26 (left)
PhotoDisc, Inc., 16 (acorns), 17
Unicorn Stock Photos/Tom Edwards, 26 (right);
 Mark E. Gibson, 28–29; Jeff Greenberg, 29
Woolaroc Museum, Bartlesville, Oklahoma, 8–9

1 2 3 4 5 6 08 07 06 05 04 03

Contents

Chapter 1	Baskets and Mats	4
Chapter 2	Preparing River Cane	6
Chapter 3	After the Trail of Tears	8
Chapter 4	Making the Baskets	12
Chapter 5	A Basket for Everything	16
Chapter 6	Upside-down Baskets	20
Chapter 7	Cherokee Village Life	24
Chapter 8	The Cherokee Today	28

Features

Words to Know	30
To Learn More	30
Places to Write and Visit	31
Internet Sites	31
Index	32

Weave your own mat cushion on page 14.

See page 19 for a recipe for Cherokee cornmeal cookies.

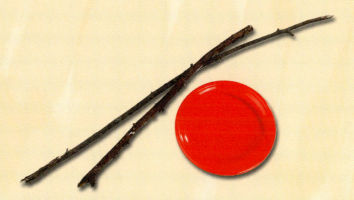

Learn on page 23 how to play a game called Disk and Pole.

Chapter One

Baskets and Mats

Many years ago, the Cherokee lived in the forests and hills of present-day Georgia. They hunted animals and grew crops for food. They wore clothing made from animal skins.

Cherokee women searched for vines, tree branches, and woody grasses in the forests. Honeysuckle vines, white oak branches, and tall, woody grasses called river cane were strong but flexible. The women could bend them without breaking them. They shaped the vines, branches, and cane into baskets and mats.

In time, weaving baskets and mats became an art form for Cherokee women. Mothers pass the skill down to their daughters.

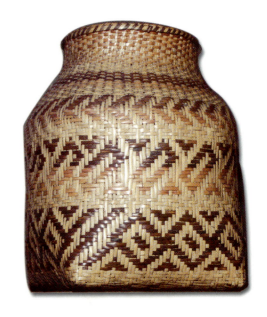

Cherokee weavers weave designs with vines, branches, and river cane.

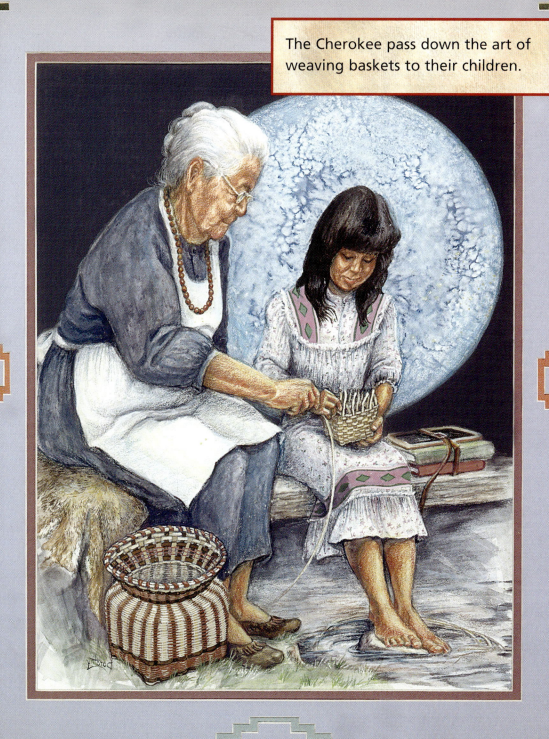

The Cherokee pass down the art of weaving baskets to their children.

The Cherokee Name

No one is exactly sure how the Cherokee got their name. It might have come from the Creek Indians. Their word "Chelokee" means "people of a different speech." They may have given this name to the Cherokee because the tribe spoke a different language.

The Cherokee first called themselves "Aniyunwiya," which means "the main people." Some Cherokee prefer their own name for the Cherokee Nation, which is "Tsalagi" (SAH-lah-gee). Spanish explorers may have had trouble saying this name. They may have pronounced the word as "Cherokee."

Chapter Two

Preparing River Cane

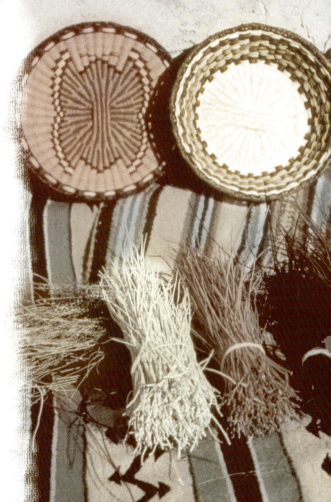

Cherokee weavers especially liked weaving with river cane. After they gathered the cane, weavers had to prepare it for weaving. They cut the cane and split it into long, thin strips. They peeled away the soft lining inside the cane. Weavers used the hard, outer layer of cane to make baskets and mats.

The next step was coloring the strips of cane. The Cherokee boiled parts of plants to make colored dyes. Bloodroot made a yellow or red dye. Black walnut made a dark brown dye. Elderberries made light red dye, while butternut made black dye. Weavers soaked strips of cane in different color dyes. When the cane was dry, the strips were ready to weave.

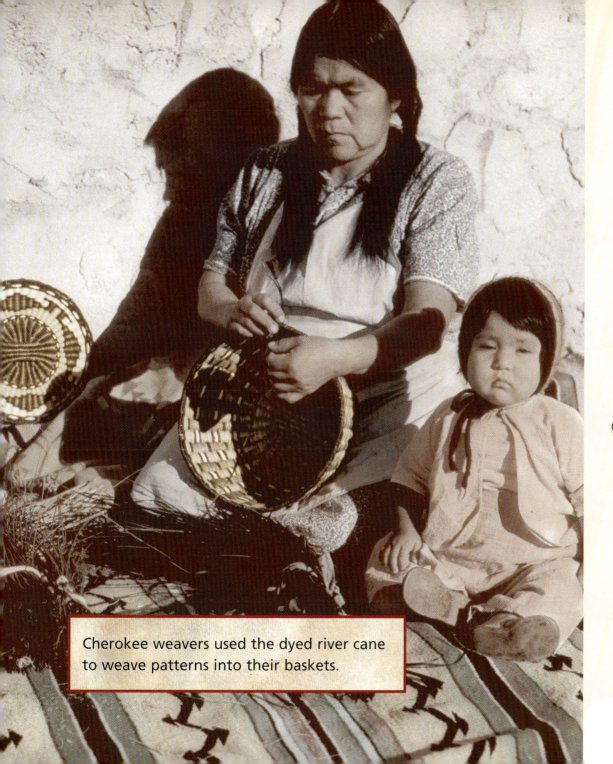

Cherokee weavers used the dyed river cane to weave patterns into their baskets.

Cherokee Medicine

The Cherokee used plants and herbs for more than dye. They often made tea or medicine from plant leaves. Other times, they crushed plants into a paste. They applied the paste to their skin. The Cherokee believed each plant had special healing powers.

The Cherokee used mint leaves to cure stomach aches.

Chapter Three

After the Trail of Tears

In the early 1800s, white settlers found gold on Cherokee land. Settlers wanted the land for themselves. Most Cherokee did not want to leave their homes.

In 1838, soldiers forced the Cherokee to move to present-day Oklahoma. The Cherokee walked or rode on horseback about 800 miles (1,300 kilometers) through snow and cold weather. Four thousand Cherokee died on this long journey. It is known as the Trail of Tears.

In Oklahoma, the Cherokee began a new way of life. River cane did not grow near their new homes. They began using white oak and honeysuckle vines once again. They also used a plant called buck brush for making baskets.

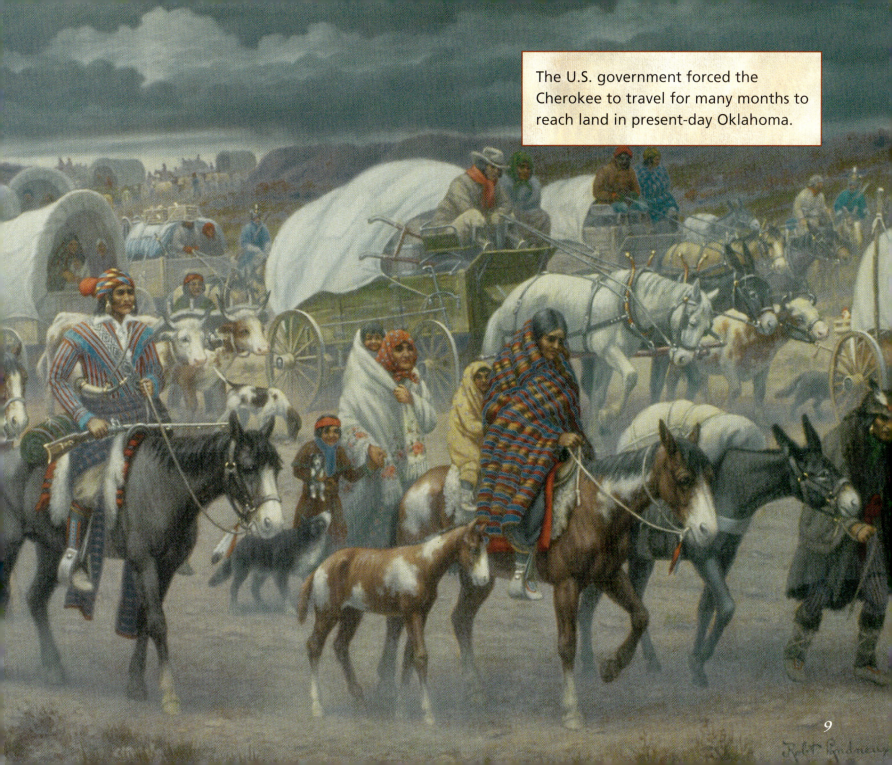
The U.S. government forced the Cherokee to travel for many months to reach land in present-day Oklahoma.

The Cherokee used some of the old methods to make materials ready for weaving. They prepared white oak in the same way they prepared river cane. They boiled, peeled, and dyed the honeysuckle and buck brush. They kept these materials in water while they worked. The vines then hardened as they dried.

After being boiled, peeled, and dried, honeysuckle could be woven into strong baskets.

Honeysuckle is a vine.

The Cherokee changed the style of their baskets in small ways. Once, Cherokee baskets had handles made of leather or vine. In Oklahoma, the Cherokee began adding carved oak handles to their baskets.

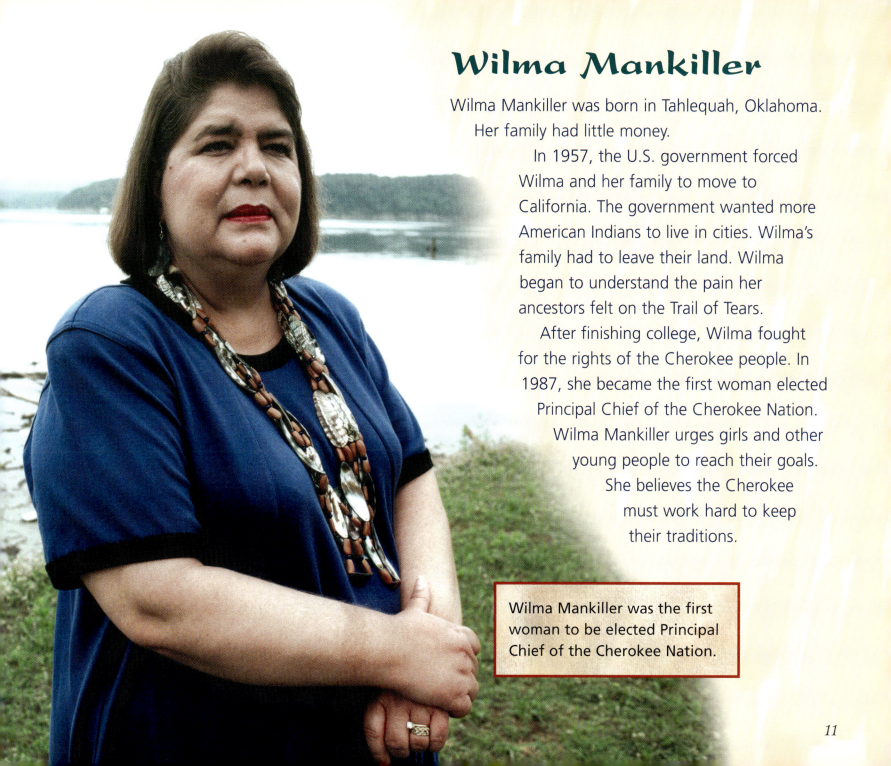

Wilma Mankiller

Wilma Mankiller was born in Tahlequah, Oklahoma. Her family had little money.

In 1957, the U.S. government forced Wilma and her family to move to California. The government wanted more American Indians to live in cities. Wilma's family had to leave their land. Wilma began to understand the pain her ancestors felt on the Trail of Tears.

After finishing college, Wilma fought for the rights of the Cherokee people. In 1987, she became the first woman elected Principal Chief of the Cherokee Nation. Wilma Mankiller urges girls and other young people to reach their goals. She believes the Cherokee must work hard to keep their traditions.

Wilma Mankiller was the first woman to be elected Principal Chief of the Cherokee Nation.

Chapter Four

Making the Baskets

Many Cherokee baskets had two layers to make them stronger. It took longer to weave the extra layer. One large two-layer basket could take up to a year to complete.

First, the weaver made a base. She gathered a bundle of strips into a circle or oval shape. She then held the bundle together with a flexible strip. When complete, the base looked like a thin circle with spokes.

Next, the weaver wove flexible strips in and out of the spokes. The basket weaver worked upward, keeping the strips even. At the top of the basket, she added a strong rim.

Cherokee baskets are sturdy and strong.

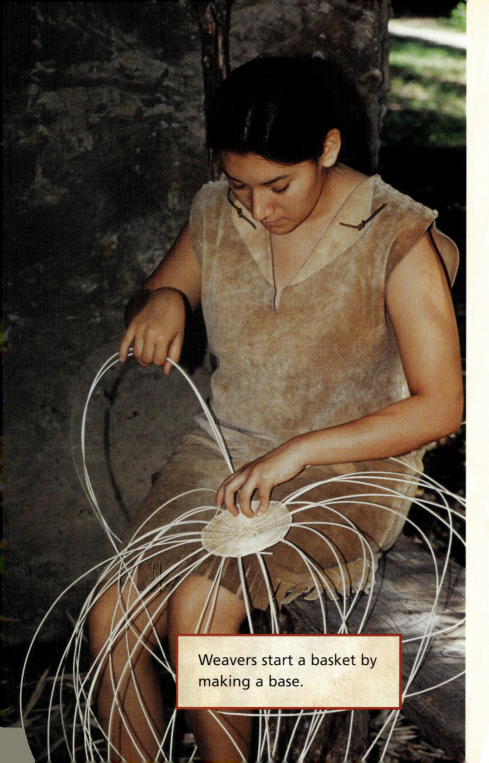

Weavers start a basket by making a base.

Other Cherokee Crafts

The Cherokee made many other crafts besides baskets. They dug clay from the ground and created pots. They used sticks and stones to draw designs in the clay. They then baked the pots in a fire.

Cherokee men carved wooden pipes, tools, and masks. Some of the masks were meant to frighten enemies. These scary masks are called booger masks. Men also carved rattles to frighten evil spirits or call upon good spirits. They made rattles from carved turtle shells. They also used small, pumpkinlike fruits called gourds to make other rattles.

Cherokee women wove beautiful designs that included zigzags, squares, and diamonds. Each weaver made up her own patterns. She sometimes varied the spaces between strips to form different designs. One design, called herringbone, looks like a fish skeleton.

Weavers begin at the bottom, weaving strips in and out of the frame.

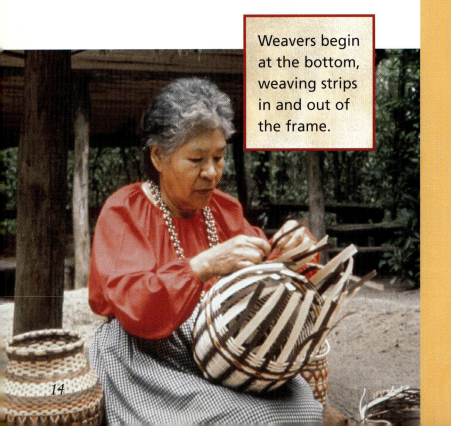

Weave a Mat Cushion

You can use the same over-and-under method of Cherokee weaving to make a cushion mat.

What You Need

16 double sheets of newspaper
flat surface
scissors
clear acrylic spray

What You Do

1. On a flat surface, fold a double sheet of newspaper in half lengthwise and crease.
2. Open the sheet and fold both edges to the center crease just made.
3. Fold both edges to the center crease one more time. Crease edges.
4. Follow steps 1 to 3 and make 15 more strips.

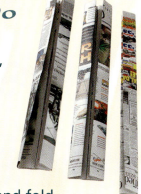

5. Lay out four strips lengthwise.
6. Weave five more strips widthwise in an over-one, under-one fashion.

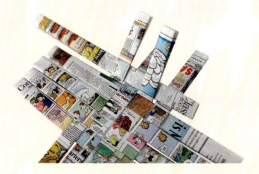

7. Adjust the strips so they are very close to one another and the ends line up neatly.
8. Weave in additional strips until there are eight strips lengthwise and eight strips widthwise.

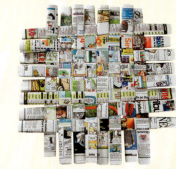

9. Begin tucking in the ends starting with strips that were last woven under the crossing strip.
10. Use scissors to trim the ends of the strips if they are too long to tuck back into the weaving. When the ends are tucked in neatly and securely, the mat will not unravel.
11. Following product directions, apply clear acrylic spray to both sides of the mat. This step will make the mat more waterproof and will keep news ink from rubbing off on skin or clothes.

Chapter Five

A Basket for Everything

The Cherokee made baskets in many shapes, each with a certain use. Tall, cone-shaped baskets were good for harvesting grain. Deep, flat-bottomed baskets held fruits, vegetables, nuts, and berries. To carry heavy loads, Cherokee men and women strapped large, deep containers called burden baskets to their backs. They wove small cone-shaped baskets to hold seeds, berries, and other small objects.

The Cherokee made baskets in many shapes and styles.

How the Milky Way Came to Be

On dark, clear nights, the Cherokee saw a wide, milky-looking band of starlight spread across the sky. Today, we call this band of light the Milky Way. The Cherokee used a special story to explain what they saw in the dark sky.

One morning, an old man and his wife found their cornmeal spilled onto the ground. Someone or something had gotten into the basket during the night. They then noticed huge paw prints in the spilled cornmeal.

The old man and woman warned the rest of the village. Villagers believed the spirit dog had disturbed the cornmeal basket. People did not want this spirit dog in their homes. The villagers planned to scare it away. The next night, they hid near the cornmeal basket.

They soon heard the sound of bird wings. Suddenly, a giant dog landed near the basket. He began gulping down the cornmeal. The hiding villagers jumped up, shaking rattles and beating drums. They frightened the dog away. At the top of a hill, he leaped into the sky.

Cornmeal spilled from the dog's mouth and fell across the sky. Each grain of cornmeal became a star. The stars formed the band of starlight called the Milky Way. The Cherokee call it "gi li' ut sun stan un' yi," which means "the place where the dog ran."

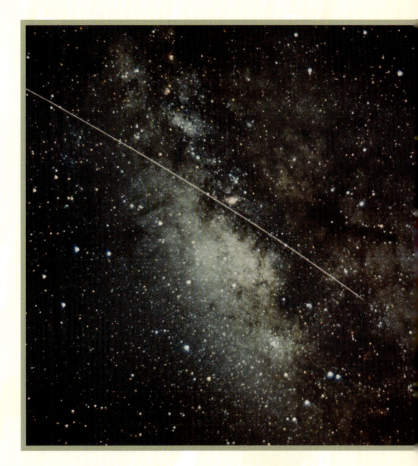

Many years ago, the Cherokee believed the Milky Way looked like grains of cornmeal spilled across the night sky.

Other baskets were useful in many ways. Women used shallow, loosely woven baskets to sift ground corn. The Cherokee made cornmeal by grinding dried corn kernels into a coarse powder. The Cherokee stored cornmeal, other food, and clothing in woven baskets of many sizes. Lids kept out dirt, insects, and rats. Some baskets were woven so tightly that the Cherokee could carry water in them.

Men used baskets when they hunted and fished. Cherokee men hunted deer, elk, and bear with bows and arrows held in large, long baskets. They used traps for fox, rabbit, turkey, and fish. Fishers carried their catch home in bucket-shaped baskets.

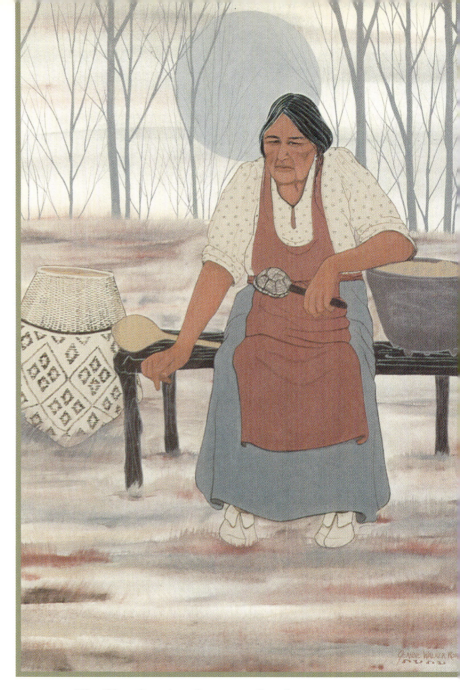

The Cherokee stored cornmeal and other food in woven baskets.

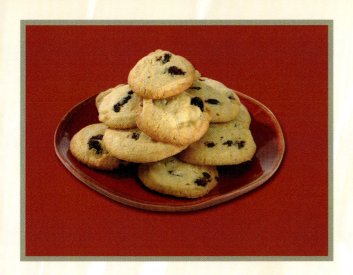

Cherokee Cornmeal Cookies

Corn was the most important food for the Cherokee. These cookies are called "se-lu i-sa u-ga-na-s-da" in Cherokee. The cookies are made with cornmeal. The Cherokee used loosely woven baskets to sift flour, cornmeal, and other grain products. They stored the grains in large, tightly woven baskets with lids to keep out dirt and pests.

What You Need

Ingredients

¾ cup (175 mL) softened butter
¾ cup (175 mL) sugar
1 egg
1 teaspoon (5 mL) vanilla
1½ cups (360 mL) flour
½ cup (120 mL) cornmeal
1 teaspoon (5 mL) baking powder
¼ teaspoon (1.2 mL) salt
½ cup (120 mL) raisins

Equipment

nonstick cooking spray
baking sheet
large mixing bowl
wooden spoon
dry-ingredient measuring cups
measuring spoons

What You Do

1. Preheat oven to 350°F (180°C).
2. Spray a baking sheet with nonstick cooking spray. Set aside.
3. With a wooden spoon, mix together butter and sugar in a large mixing bowl.
4. Add egg and vanilla. Stir until mixture is smooth.
5. Add flour, cornmeal, baking powder, salt, and raisins. Mix well.
6. Drop the dough by the spoonful onto the baking sheet. Bake for about 15 minutes, until the cookies are lightly browned.

Makes about 1 dozen cookies

Chapter Six

Upside-down Baskets

Cherokee houses looked like upside-down baskets. To build them, the Cherokee placed poles in the ground to form a rectangle. They wove cane and tree branches through these poles, leaving a space for a door. Each house had a peaked or flat roof on top. They covered the walls with mud and the roof with bark.

Inside the house, Cherokee women placed woven mats over the floors. They made beds from woven mats and animal skins. A child's mat was about 20 inches (51 centimeters) wide and 30 inches (76 centimeters) long. An adult's mat was up to 5 feet (1.5 meters) wide and 8 feet (2.4 meters) long.

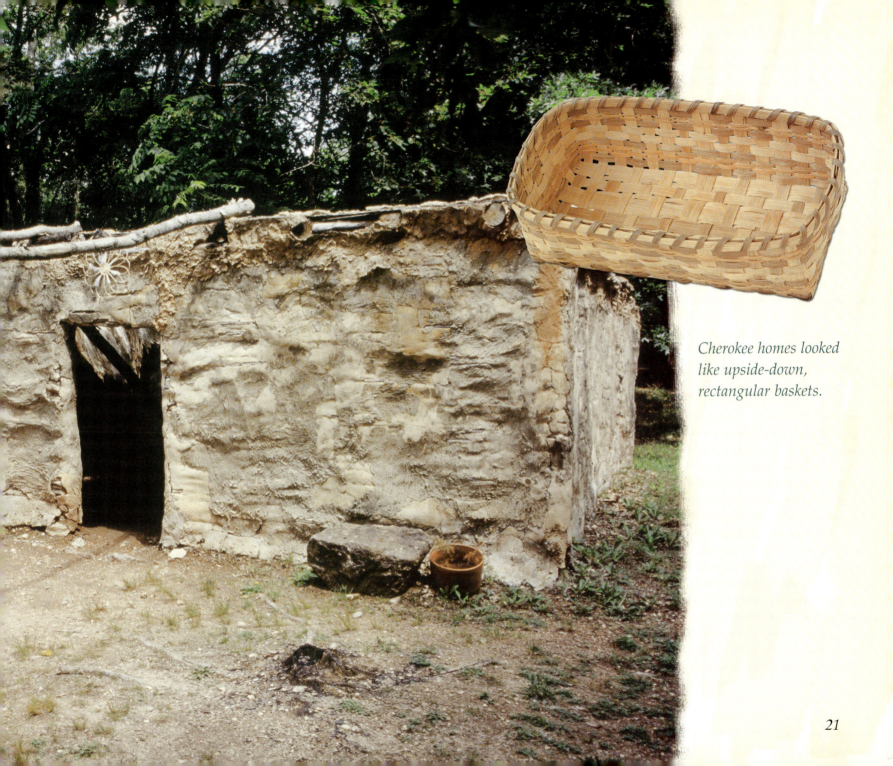

Cherokee homes looked like upside-down, rectangular baskets.

Cherokee villages had 30 to 60 homes. Each home had a main house for living and a smaller house for ceremonies. The o-si was a small, round building next to the main house. The o-si roof was made of woven grass and tree bark. The Cherokee decorated o-si walls with mats and covered the floors with more mats. They used the o-si for healing and other ceremonies.

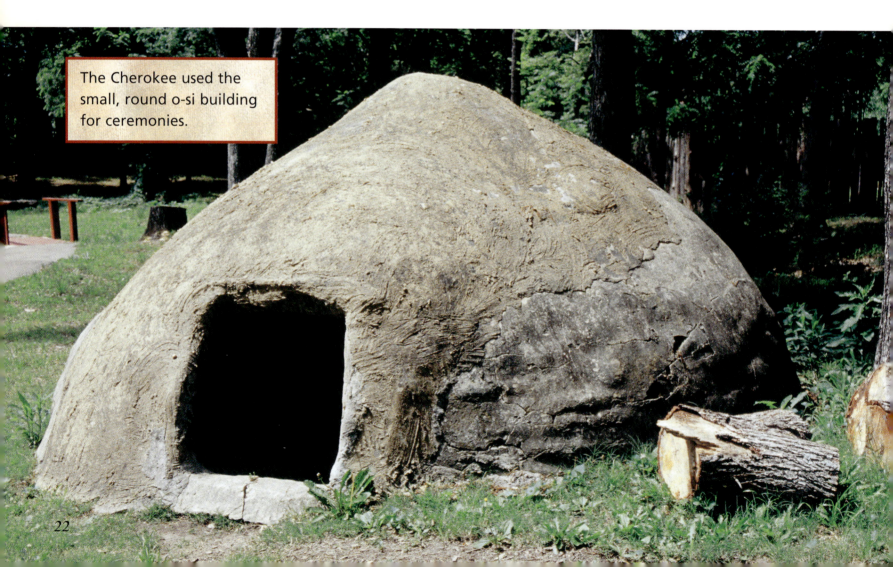

The Cherokee used the small, round o-si building for ceremonies.

Disk and Pole (Tsung-Sy'Unvi)

A game called tsung-sy'unvi was popular among Cherokee men and boys. They believed the game was good practice for throwing a spear.

What You Need

a small, plastic plate
one long stick for each player
three or more players

What You Do

1. One player rolls the plate on its edge in an open area.
2. Two other players run after the rolling plate. These players throw their sticks to land where they think the plate will stop.
3. The player who gets the tip of the stick closest to the spot where the plate stops rolling earns one point.
4. The person with the most points after five rolls wins the game.

Chapter Seven

Cherokee Village Life

Cherokees who shared a common ancestor belonged to a certain clan. The seven Cherokee clans were called Wolf, Deer, Bird, Longhair, Wild Potato, Blue, and Paint. Each member of a clan treated one another like brothers and sisters. Every Cherokee village was made up of different clan members.

Each Cherokee village had a council house big enough to hold all the villagers at one time. This building was made of woven young trees covered with mud. People gathered at the council house for weddings and other ceremonies. Villagers also met to discuss which clans would farm and which clans would hunt.

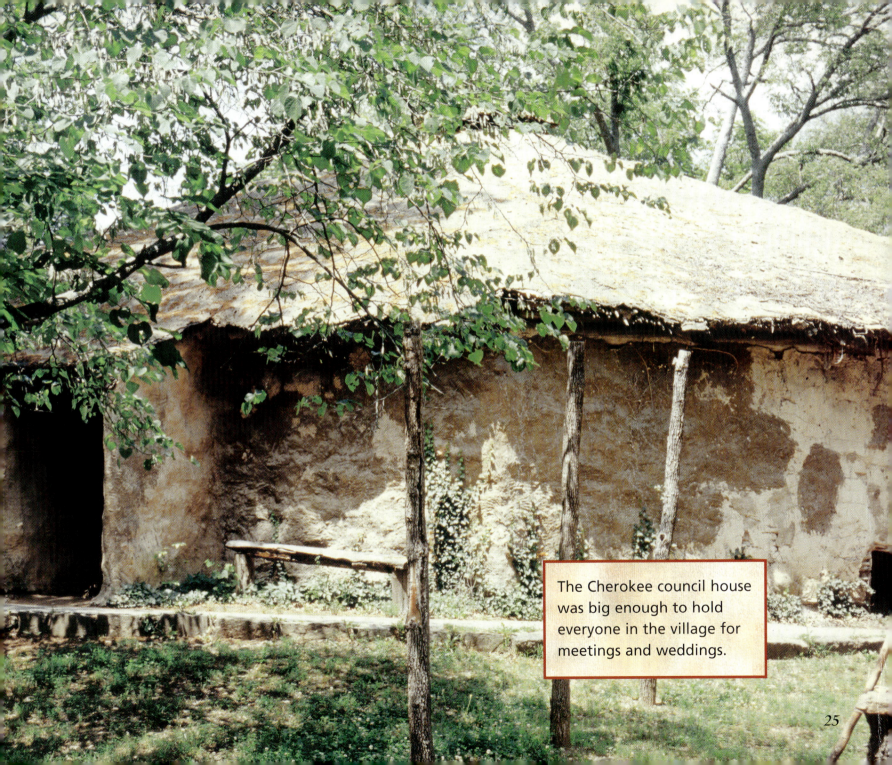

The Cherokee council house was big enough to hold everyone in the village for meetings and weddings.

Comfortable mats covered council house benches. These mats had colorful zigzag, diamond, and square designs. The designs matched many Cherokee baskets. Mats hanging on the walls had woven symbols of the Cherokee clans. These mats showed where each clan was assigned to sit.

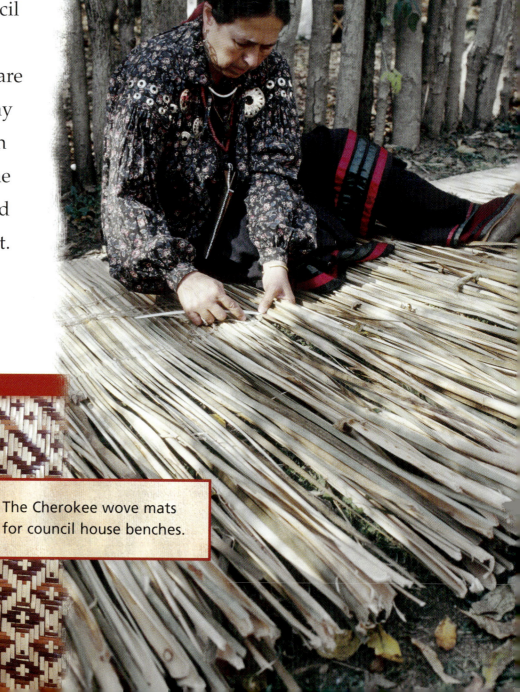

The Cherokee wove mats for council house benches.

Cherokee Weddings

Men and women were only allowed to marry people from different clans. They first asked an elder whether their marriage would be a good decision. The chief then placed a root in the palms of his hands and said a prayer. If the roots moved while he prayed, the couple could be married. If the roots withered, marriage was not allowed.

Wedding ceremonies lasted about 30 minutes. The bride and groom met in the council house. The man gave his bride a piece of deer meat. This act was a promise to provide food for their family. The woman gave the groom an ear of corn. This act was a promise to take good care of the home. After the ceremony, family and friends joined the new couple in a large feast.

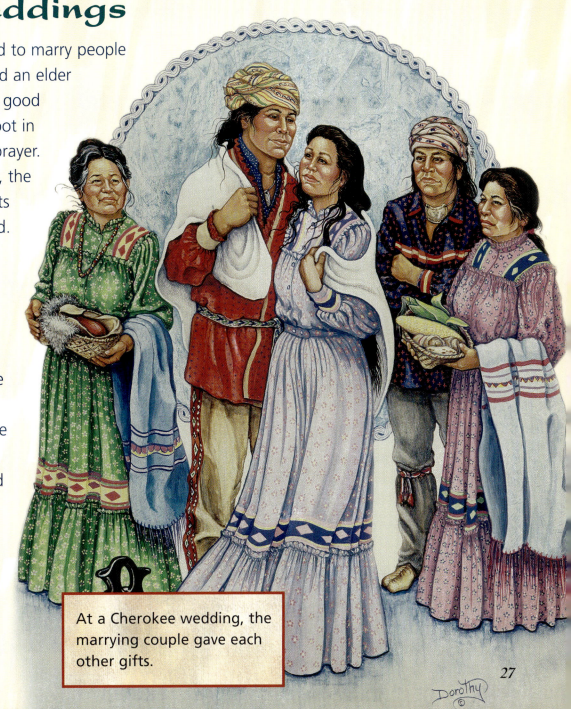

At a Cherokee wedding, the marrying couple gave each other gifts.

Chapter Eight

The Cherokee Today

Today, the Cherokee try to practice their ancestors' traditions whenever they can. The Eastern and Western Bands of Cherokee continue tribal customs. The Oconaluftee Indian Village in North Carolina provides lessons in weaving, pottery, beadwork, and other Cherokee crafts.

In Oklahoma, the Qualla Arts and Crafts Mutual helps Cherokee artists and crafters earn a living. The Cherokee people want to be sure that the traditions they learned from their ancestors continue in the future.

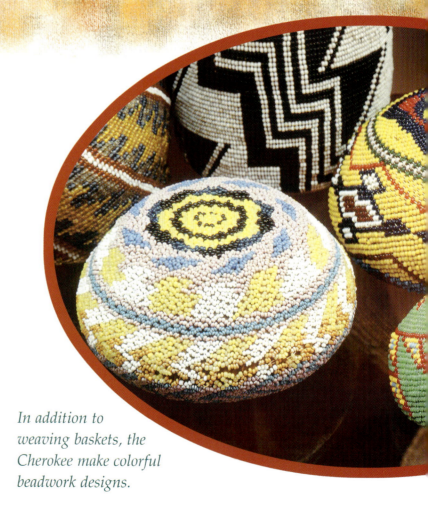

In addition to weaving baskets, the Cherokee make colorful beadwork designs.

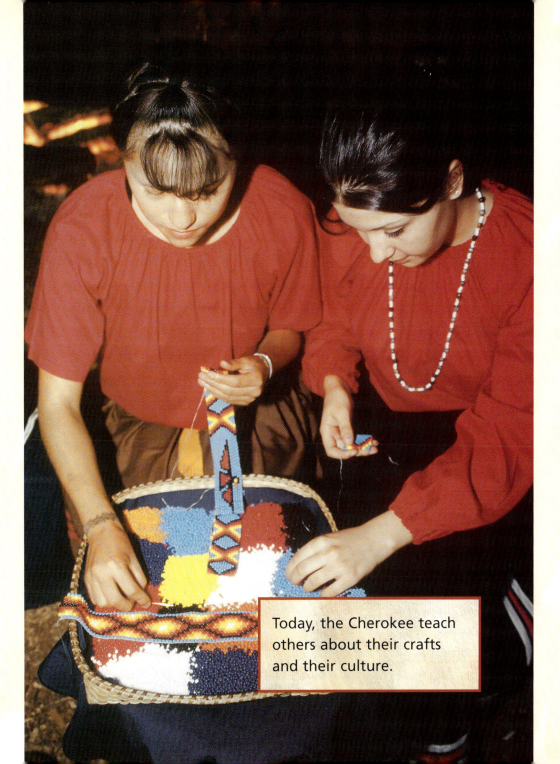

Today, the Cherokee teach others about their crafts and their culture.

Words to Know

adapt (uh-DAPT)—to change to fit into a new environment

ancestor (AN-sess-tur)—a member of a family or relation who lived long ago

ancient (AYN-shunt)—very old

cane (CAYN)—a type of plant or grass that has a hollow, woody stem

ceremony (SER-eh-moh-nee)—formal actions, words, or music that honor a person, an event, or a higher being

flexible (FLEK-suh-buhl)—able to bend

layer (LAY-ur)—a single thickness of something

material (ma-TEER-ee-uhl)—the things from which something is made

tradition (truh-DISH-uhn)—a custom, idea, or belief that is passed on to younger people by older relatives or tribal members

vine (VINE)—a plant with a long stem that clings to the ground, a wall, or a fence as it grows

To Learn More

Gaines, Richard. *The Cherokee.* Native Americans. Edina, Minn.: Abdo, 2000.

Long, Cathryn J. *The Cherokee.* Indigenous Peoples of North America. San Diego: Lucent Books, 2000.

Lund, Bill. *The Cherokee Indians.* Native Peoples. Mankato, Minn.: Bridgestone Books, 1997.

Roop, Peter, and Connie Roop. *If You Lived with the Cherokee.* New York: Scholastic, 1998.

Places to Write and Visit

Cherokee Heritage Center
Keeler Road
P.O. Box 515
Tahlequah, OK 74465-0515

Museum of the Cherokee Indian
Highway 441 and Drama Road
P.O. Box 1599
Cherokee, NC 28719-1599

Cherokee Trail of Tears Park
9th Street and Skyline Drive
Hopkinsville, KY 42241

Sequoyah Birthplace Museum
576 Highway 360, Citico Road
P.O. Box 69
Vonore, TN 37885-0069

Internet Sites

Track down many sites about the Cherokee.
Visit the FACT HOUND at *http://www.facthound.com*

IT IS EASY! IT IS FUN!

1) Go to *http://www.facthound.com*
2) Type in: 073681535X
3) Click on "FETCH IT" and FACT HOUND will find several links hand-picked by our editors.

Relax and let our pal FACT HOUND do the research for you!

LA GRANGE PUBLIC LIBRARY
10 WEST COSSITT
LA GRANGE, ILLINOIS 60525

Index

beadwork, 28
buck brush, 8, 10
burden baskets, 16

carving, 10, 13
ceremony, 22, 24, 27. See also wedding
Cherokee Nation, 5, 11
clan, 24, 26, 27
clothing, 4, 18
cornmeal, 17, 18, 19
council house, 24, 25, 26, 27

design, 4, 13, 14, 26, 28
dye, 6, 7, 10

farming, 16, 24
fishing, 18
food, 4, 16, 18, 19, 27

game, 23

handles, 10
home, 4, 8, 17, 20, 21, 22, 27
hunting, 4, 18, 24

Mankiller, Wilma, 11
mat, 20, 22, 26
medicine, 7

name, 5

Oklahoma, 8, 9, 10, 11, 28
o-si, 22

pottery, 13, 28

river cane, 4, 6, 7, 8, 20

Trail of Tears, 8, 9, 11

village, 22, 24, 25
vine, 4, 8, 10

wedding, 24, 25, 27
white oak, 4, 8, 10